SOUND ™DEEP WATERS

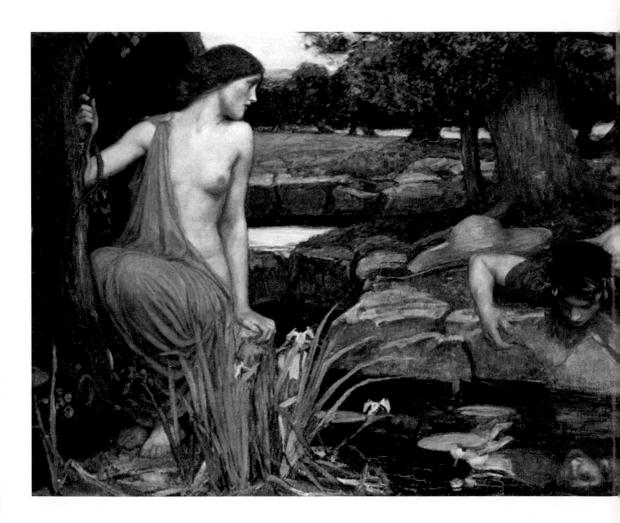

Women's Romantie Poetry in the Vietorian Age

> Edited by Pamela Norris

The Overlook Press New York, NY This edition first published in hardcover in the United States in 2016 by The Overlook Press, Peter Mayer Publishers, Inc.

> 141 Wooster Street New York, NY 10012 www.overlookpress.com

Introduction, biographies and selection © 1991, 2016 by Pamela Norris

See page 120 for further acknowledgements

All rights reserved. No part of this book may be reproduced in any form or by any electronic or mechanical means, including information storage and retrieval systems, without permission in writing from the publisher, except by a reviewer who may quote brief passages in a review.

ISBN 978-1-4683-1265-2

Cataloging in Publication Data available from the Library of Congress

1 3 5 7 9 10 8 6 4 2

Printed in China

Title Page: Echo & Narcissus by J. M. Waterhouse

CONTENTS

Introduction

7

LOVE'S BITTER-SWEETS	
Love and Friendship Emily Jane Brontë	14
A Love Token Adelaide Anne Procter	17
Go From Me Elizabeth Barrett Browning	18
The Long White Seam Jean Ingelow	21
Wild Nights Emily Dickinson	22
A Birthday Christina Rossetti	25
The Mountain Maid Dora Sigerson Shorter	26
The Elixir Emma Lazarus	28
The Singer Lizette Woodworth Reese	31
Echo Christina Rossetti	32
A Shattered Lute Alice Meynell	35
Hora Stellatrix Amy Lowell	36

MOMENTS OF DELIGHT

A Windy Day Anne Brontë	41
The Best Thing in the World Elizabeth Barrett Browning	43
Morning Song Edith Nesbit	44
Poppies on the Wheat Helen Jackson	47
Blackberry Blossoms Lizette Woodworth Reese	49
I Taste a Liquor Emily Dickinson	50
Brother and Sister George Eliot	52
The Autumn Day its Course has Run Charlotte Brontë	54
A Novice Dollie Radford	57
Behind a Wall Amy Lowell	58
A Lost Chord Adelaide Anne Procter	61
Youth Emma Lazarus	62

DREAMS AND REALITIES

I Stepped from Plank to Plank Emily Dickinson	66
Crossed Threads Helen Jackson	69
Two Lovers George Eliot	70
Grief Elizabeth Barrett Browning	71
A Scherzo Dora Greenwell	75
Passing and Glassing Christina Rossetti	76
Solitude Ella Wheeler Wilcox	78
Worn Out Elizabeth Siddal	81
Petals Amy Lowell	82
The Old Stoic Emily Jane Brontë	84
The Other Side of a Mirror Mary Elizabeth Coleridge	87
Up-hill Christina Rossetti	88

LAST SONGS

The Watcher in the Wood Dora Sigerson Shorter	93
A Reminiscence Anne Brontë	94
An End Christina Rossetti	96
I Died for Beauty Emily Dickinson	99
Remembrance Emily Jane Brontë	100
On the Threshold Amy Levy	102
Maternity Alice Meynell	105
Cold and Quiet Jean Ingelow	107
Last Words Helen Jackson	108
Youth and Death Emma Lazarus	111
Age and Death Emma Lazarus	111
Song Christina Rossetti	112
THE POETS	114
INDEX	119

ACKNOWLEDGEMENTS	120

INTRODUCTION

Poetry was widely read in the Victorian period, both for entertainment and as a guide to correct behavior. Married women could consult Coventry Patmore's "The Angel in the House," where the ideal wife is described as a domestic saint, whose purity and goodness protect the home—and her husband—against the grossness of the outside world. Tennyson's poem "The Princess" is equally clear about woman's proper place in the social hierarchy:

Man for the field and woman for the hearth: Man for the sword and for the needle she: Man with the head and woman with the heart: Man to command and woman to obey, All else confusion.

The Victorians liked their women to be angels and they preferred them to be based very firmly in the home. A consequence of this focus on woman's domestic role was that practical or creative work outside the home came to be considered degrading or too stressful for middle-class women. Prosperous families had servants to care for the children and cope with the physical drudgery required to maintain substantial households. Apart from charity work, or, for spinsters in straitened circumstances, the often-demeaning role of governess, women were expected to devote themselves to their husbands, children, and social lives, and to the pursuit of elegant and well-groomed leisure. Strumming on the piano, painting delicate watercolors of flowers, or making shell-boxes were considered desirable ways of filling the long hours between breakfast and bedtime. A little light reading was also approved, suitable to woman's less well-developed mental faculties.

But what did women themselves want? Were they content to be subservient to the male members of the household? And how did they feel about focusing their energies on their families and undemanding hobbies rather than making a serious attempt to develop their own interests and abilities? In her verse-novel *Aurora Leigh*, Elizabeth Barrett Browning mocks the "symbolical" works of women:

We sew, sew, prick our fingers, dull our sight, Producing what? A pair of slippers, sir, To put on when you're weary—or a stool To stumble over and vex you..."curse that stool!"

The poets represented in *Sound the Deep Waters* suggest, both in their lives and their poetry, that for many women the reality was very different from the popular stereotypes.

One myth that their lives explode is that of the comfortable home supported by the male breadwinner. There was considerable variety in the living circumstances of these writers. The Brontë sisters grew up in a remote parsonage at Haworth in Yorkshire. All three worked as teachers or governesses, roles that they hated. Their brief lives were marked by poverty, isolation, and hard creative effort, while their powerful, often heroic feelings struggled for expression within the narrow boundaries of their external circumstances. The poems included in this anthology demonstrate different aspects of their personalities: Charlotte's melancholy introspection, Anne's sympathetic response to nature and human love, and Emily's uncompromising claim to emotions that would generally have been regarded as unwomanly or even sacrilegious.

Like Charlotte Brontë, Elizabeth Barrett Browning married comparatively late, running away from her possessive father to live in Italy with the poet Robert Browning, giving birth to a son when she was 43, and continuing to be a productive and popular poet until her early death. Elizabeth's more affluent family circumstances meant that, unlike the Brontës, she was free to devote her energies wholeheartedly to writing. Largely self-taught, she made a point of mastering knowledge that was customarily a male prerogative, and her intelligence and learning are expressed in the poetry she published, along with her sensitivity and capacity for intense feeling. Here, she gaily reminds us that "The Best Thing in the World" is "Love, when, *so*, you're loved again." A darker poem, "Grief," is illustrated by Anna Lea Merritt's "War," a powerful and moving painting, in which a woman seems frozen with shock on hearing some terrible news.

Women could be the main breadwinners in their families. The need to house and feed a growing troop of children provided the incentive for many women to write for publication. Edith Nesbit was a prolific writer of verse before she established herself as a novelist for children. In the early years of her marriage to fellow Fabian Herbert Bland, their household (which included two of his "love" children and their mother) largely relied on Edith's pen for the lentil and bean dishes with which she nourished her dependents when times were hard. Alice Meynell also wrote to support an extensive family. Other writers remained resolutely single. Christina Rossetti

8

evaded two offers of marriage to live quietly at home with her mother, writing her poems in a little back room in moments of leisure from household duties and her charitable work for "fallen" women. The American poet, Emily Dickinson, was even more reclusive, establishing her right to retire from family life as often as she chose, and writing hundreds of poems, the majority unpublished in her lifetime and kept locked away in a chest.

The poems in *Sound the Deep Waters* reflect the diverse interests and experiences of the poets. In LOVE'S BITTER-SWEETS, Emily Brontë compares love to the wild rose-briar, blossoming in summer, but withering in winter. Christina Rossetti's "A Birthday" celebrates joyous meeting with the beloved; in "Echo" she bitterly laments lost love. In "Go From Me," written in the first flush of her passion for Robert Browning, Elizabeth Barrett Browning describes the invasive power of love: "What I do / And what I dream include thee, as the wine / Must taste of its own grapes." Emma Lazarus's "The Elixir" reminds the reader that love cannot be forced. In "The Singer," Lizette Woodworth Recse draws on folk-tale traditions for a magical story of love and time.

Death, explored in LAST SONGS, was also a favorite theme, perhaps not surprisingly at a period of high infant and maternal mortality. Alice Meynell's "Maternity" angrily rejects the pious platitudes so often trotted out to console a bereaved mother. Emily Brontë, in "Remembrance," writes with astonishing honesty of the need to check grief and get on with living. In a characteristically enigmatic poem, "I Died for Beauty," Emily Dickinson asks challenging questions about art and fame.

It wasn't all doom and gloom. MOMENTS OF DELIGHT celebrates life's pleasures. Dollie Radford relishes a cigarette in the midst of domestic chaos. George Eliot wistfully recalls childhood fishing expeditions with her brother, from whom she was estranged after she set up home with a married man, George Henry Lewes. Amy Lowell finds solace "Behind a Wall," in her imaginary garden, and in her famous poem, "A Lost Chord," Adelaide Anne Procter is overwhelmed by the power of music.

DREAMS AND REALITIES explores the poets' attempts to find meaning and structure in life. Ella Wheeler Wilcox's "Solitude" famously begins: "Laugh, and the world laughs with you; / Weep, and you weep alone." In Mary Elizabeth Coleridge's "The Other Side of a Mirror," a woman gazes in horror at her true self, reflected in her mirror." Emily Brontë is made of sterner stuff. In "The Old Stoic," she vaunts "a chainless soul, / With courage to endure." Christina Rossetti's exquisite poem, "Up-hill," concludes this section, with its glimpse of the welcome and peace at the end of life's strenuous journey.

The title of this anthology, *Sound the Deep Waters*, is taken from the first line of another poem by Christina Rossetti. Too long to be included in the collection, "Sleep at Sea" tells the story of a boat full of dreaming sailors. As the ship races through gigantic rocks towards a raging tempest, spirits struggle to alert the sleepers to their duties in the real world. It is a reminder of the dangers of day-dreaming. Lost in reverie, a person may forget to take control of the ship of life, which for Christina meant paying attention to the soul's welfare. In the poems in this collection, there is an abundance of dreams, but the poets are equally fascinated by the joys and pains and duties of everyday life, writing with a realism and artistry that still speaks to the reader in the twenty-first century.

The poems in Sound the Deep Waters are accompanied by paintings, by both male and female artists. It was a time of change, when convention and innovation battled for control in the visual arts. In 1848 seven young men started a new artistic movement in revolt against what they criticized as the trite conventions of Establishment art. Known as the Pre-Raphaelite Brotherhood, the group included William Holman Hunt, John Everett Millais, and two of Christina Rossetti's brothers: the artist and poet Dante Gabriel Rossetti and the critic William Michael Rossetti. The aims of the movement can be summarized as the choice of serious or high-minded subject matter, "natural" or realistic depiction of images, brilliant color, and an accretion of symbolic detail. As well as "real-life" subjects, stories from contemporary and early Italian poets, and from mediaeval legend were richly and imaginatively depicted. Holman Hunt's "Isabella and the Pot of Basil" and Millais' "Mariana in the Moated Grange" illustrate scenes from Keats and Tennyson. Dante Gabriel Rossetti developed his own interpretation of the Brotherhood's tenets in romantic and idealized representations of women: a brooding "Proserpine," seconds after she has sampled the pomegranate seeds that will keep her underground as Pluto's bride for six months in every year; a pensive maiden in "Reverie"; the lush imagery of "The Beloved" and "La Ghirlandata." Different strands developed from the Brotherhood's initial impetus for change: Burne-Jones and John William Waterhouse developed their own idiosyncratic mythologies. Other styles of painting flourished alongside the Pre-Raphaelites and are represented in Sound the Deep Waters by such works as Thomas Cooper Gotch's highly individual "The Child Enthroned," and the delightful portraits of children and young women by the Anglo-French artist Sophie Anderson.

Victorian women artists also battled against female stereotypes. Thanks to the enthusiasm of art historians and biographers, much more is now known about their lives and achievements, and the images in *Sound the Deep Waters* display their range and diversity. Despite the difficulty of acquiring training and display of their work, some women artists did achieve status and recognition. It helped to have an artist brother or father with a studio and contacts. Many of the women artists included in these pages were directly connected with or influenced by the Pre-Raphaelite movement. Marie Spartali Stillman was a noted "stunner" (Pre-Raphaelite slang for an attractive woman) and sat for Rossetti and Burne-Jones as well as the photographer Julia Margaret Cameron. She studied with Ford Madox Brown along with his daughters Catherine and Lucy, and her watercolors were often inspired by the Italian poets. "By a Clear Well, Within a Little Field" refers to a sonnet by Boccaccio. The Birmingham artist, Kate Elizabeth Bunce, was influenced by Rossetti in style and subject matter. 'The Chance Meeting" captures a momentary contact between the Italian poet Dante and his beloved Beatrice. "Undine" is probably the work of Louisa Starr, who became the first female gold medalist at the Royal Academy Schools in 1867. It offers a variation on the classic tale of the supernatural maiden, in this case a water nymph, who marries a human to acquire a soul. Predictably Undine is deserted for an carthly lover and appears at a suitably inappropriate moment, veiled as a bride and wringing her hands with despair as she claims the life of her faithless husband.

Among the most striking of the artists in these pages is Evelyn Pickering de Morgan. Educated for marriage by her wealthy family, she studied art in secret until reluctantly allowed to attend the Slade School of Art. She went on to develop a career of distinction, and works such as "Queen Eleanor and Fair Rosamund,""Port after Stormy Seas," and "The Prisoner" display her originality, love of color, detail, and pictorial symbolism, and her interest in neo-classical as well as traditionally Pre-Raphaelite subjects. "Flora," painted in Florence and clearly influenced by Botticelli's "Primavera," is particularly fine. "The Worship of Mammon" exhibits a characteristic interest in moral issues.

As this brief introduction suggests, there was considerably more to life for the Victorian woman than the "hearth," "needle," and emotional empathy that Tennyson's poem endorses. The poems in *Sound the Deep Waters* offer a unique insight into women's lives through the thoughts, feelings, ambitions, and desires that their words so eloquently express. The paintings that accompany the poems suggest the dream worlds that played so important a role in Victorian culture, and to which both men and women made a vital contribution, as writers, artists, explorers, and innovators through the sixty-odd years of Queen Victoria's reign.

Pamela Norris

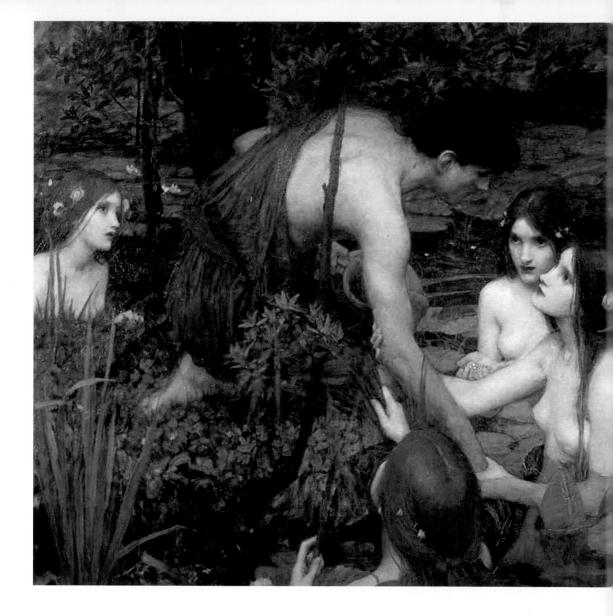

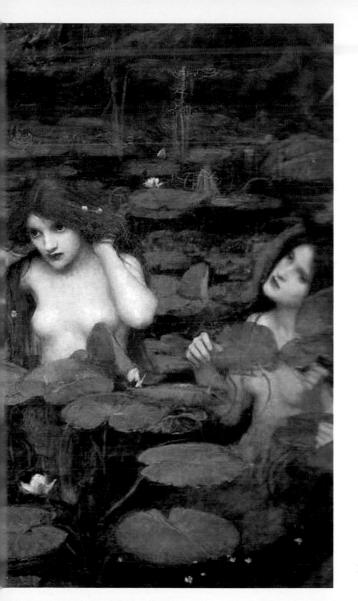

LOVE'S BITTER-SWEETS

Love is like the wild rose-briar;

EMILY JANE BRONTË

HYLAS AND THE NYMPHS John William Waterhouse

LOVE and FRIENDSHIP

Love is like the wild rose-briar; Friendship like the holly-tree. The holly is dark when the rose-briar blooms, But which will bloom most constantly?

The wild rose briar is sweet in spring, Its summer blossoms scent the air; Yet wait till winter comes again. And who will call the wild-briar fair?

Then, scorn the silly rose-wreath now, And deck thee with the holly's sheen, That, when December blights thy brow, He still may leave thy garland green.

EMILY JANE BRONTË

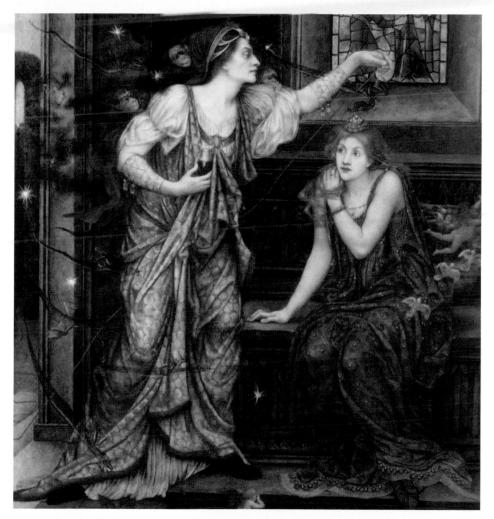

QUEEN ELEANOR AND FAIR ROSAMUND Evelyn de Morgan

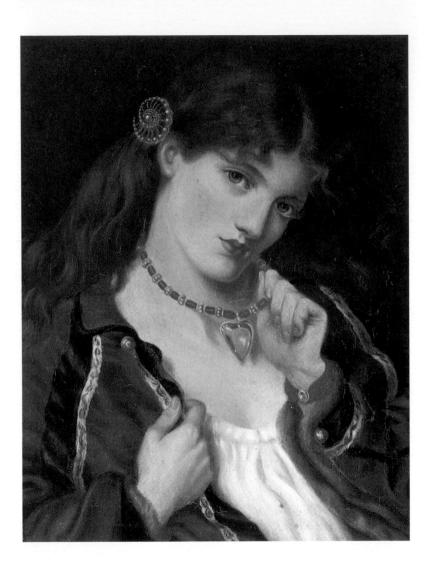

A LOVE TOKEN

Do you grieve no costly offering To the Lady you can make? One there is, and gifts less worthy Queens have stooped to take.

Take a Heart of virgin silver, Fashion it with heavy blows, Cast it into Love's hot furnace When it fiercest glows.

With Pain's sharpest point transfix it. And then carve in letters fair, Tender dreams and quaint devices, Fancies sweet and rare. Set within it Hope's blue sapphire, Many-changing opal fears, Blood-red ruby-stones of daring, Mixed with pearly tears.

And when you have wrought and laboured Till the gift is all complete. You may humbly lay your offering At the Lady's feet.

Should her mood perchance be gracious-With disdainful smiling pride, She will place it with the trinkets Glittering at her side.

ADELAIDE ANNE PROCTER

JOLIE COEUR (after Rossetti) Marie Spartali Stillman

GOFROMME

Go from me. Yet I feel that I shall stand Henceforward in thy shadow. Nevermore Alone upon the threshold of my door Of individual life, I shall command The uses of my soul, nor lift my hand Serenely in the sunshine as before. Without the sense of that which I forebore -Thy touch upon the palm. The widest land Doom takes to part us, leaves thy heart in mine With pulses that beat double. What I do And what I dream include thee, as the wine Must taste of its own grapes. And when I sue God for myself, He hears that name of thine, And sees within my eyes the tears of two.

No. VI of 'Sonnets from the Portuguese'

ELIZABETH BARRETT BROWNING

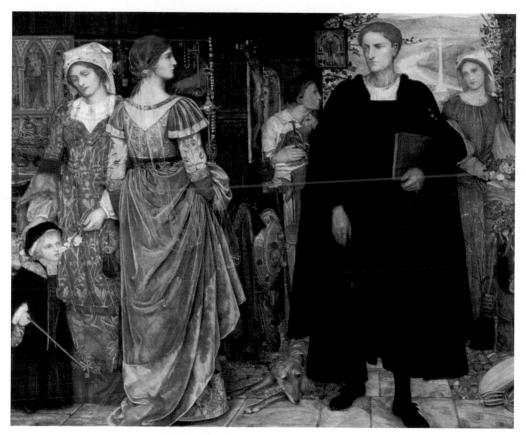

THE CHANCE MEETING KATE ELIZABETH BUNCE

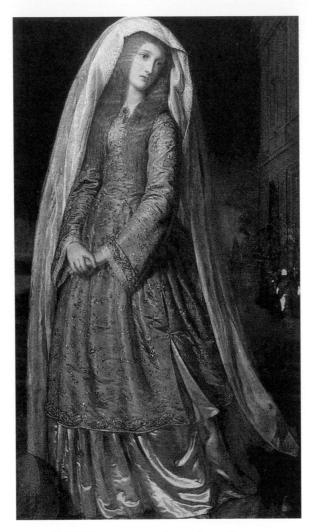

UNDINE, ATTRIBUTED TO LOUISA STARR CANZIANI

THE LONG WHITE SEAM

As I came round the harbour buoy, The lights began to gleam, No wave the land-locked water stirred, The crags were white as cream; And I mark my love by candle light Sewing her long white seam. It's aye scwing ashore, my dear, Watch and steer at sea, It's reef and furl, and haul the line, Set Sail and think of thee.

I climbed to reach her cottage door; O sweetly my love sings! Like a shaft of light her voice breaks forth, My soul to meet it springs As the shining water leaped of old When stirred by angel wings. Aye longings to list anew Awake and in my dream, But never a song she sang like this,

Sewing the long white seam.

Fair fall the lights, the harbour lights,
That brought me in to thee,
And peace drop down on that low roof
For the sight that I did see,
And the voice, my dear, that rang so clear
All for the love of me.
For O, for O, with brows bent low
By the candle's flickering gleam
Her wedding gown it was she wrought,
Sewing the long white seam.

JEAN INGELOW

WILD NIGHTS

Wild Nights - Wild Nights! Were I with thee Wild Nights should be Our luxury!

Futile - the Winds -To a Heart in port -Done with the Compass -Done with the Chart!

Rowing in Eden – Ah, the Sea! Might I but moor – Tonight In Thee!

EMILY DICKINSON

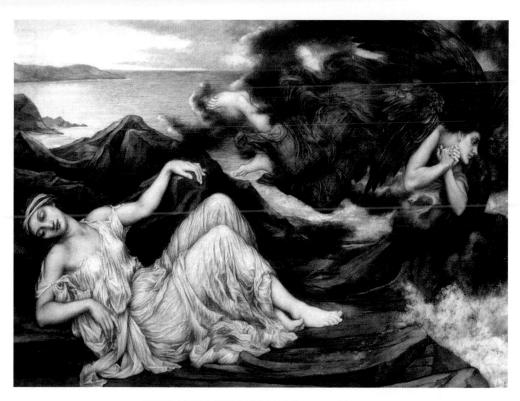

PORT AFTER STORMY SEAS, EVELYN DE MORGAN

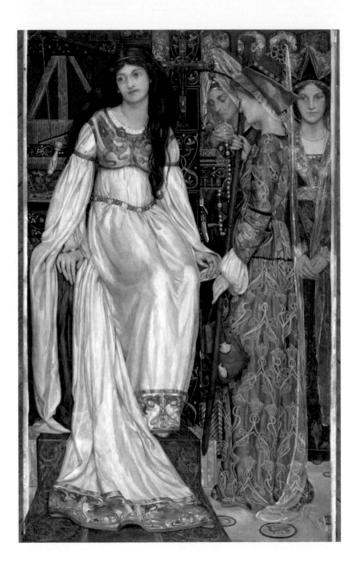

A BIRTHDAY

My heart is like a singing bird

Whose nest is in a watered shoot; My heart is like an appletree Whose boughs are bent with thickset fruit; My heart is like a rainbow shell

That paddles in a halcyon sea; My heart is gladder than all these Because my love is come to me.

Raise me a dais of silk and down; Hang it with vair and purple dyes; Carve it in doves, and pomegranates, And peacocks with a hundred eyes; Work it in gold and silver grapes, In leaves, and silver fleurs-de-lys; Because the birthday of my life Is come, my love is come to me.

CHRISTINA ROSSETTI

THE KEEPSAKE, KATE ELIZABETH BUNCE

THE MOUNTAIN MAID

Half seated on a mossy crag, Half crouching in the heather; I found a little Irish maid, All in June's golden weather.

Like some fond hand that loved the child, The wind tossed back her tresses; The heath-bells touched her unclad feet With shy and soft caresses.

A mountain linnet flung his song Into the air around her; But all in vain the splendid hour, For deep in woe I found her. Ahone! Ahone! Ahone!' she wept. The tears fell fast and faster; I sat myself beside her there, To hear of her disaster.

Like dew on roses down her cheek The diamond drops were stealing; She laid her two brown hands in mine, Her trouble all revealing.

Alas! Alas! the tale she told In Gaelic low and tender; A plague upon my Saxon tongue, I could not comprehend her.

DORA SIGERSON SHORTER

GIRL IN WHITE, SOPHIE ANDERSON

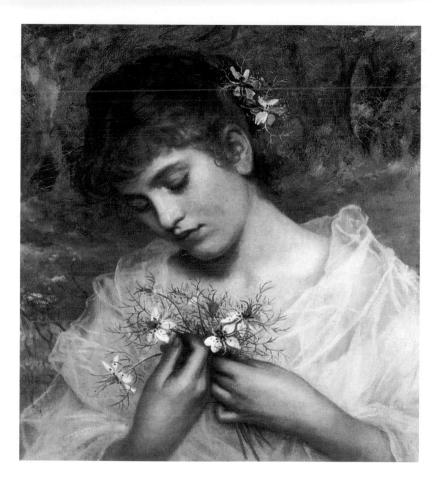

THE EUXIR

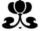

'Oh brew me a potion strong and good! One golden drop in his wine Shall charm his sense and fire his blood. And bend his will to mine.'

Poor child of passion! ask of me Elixir of death or sleep, Or Lethe's stream; but love is free, And woman must wait and weep.

EMMA LAZARUS

MORGAN-LE-FAY, ANTHONY FREDERICK SANDYS

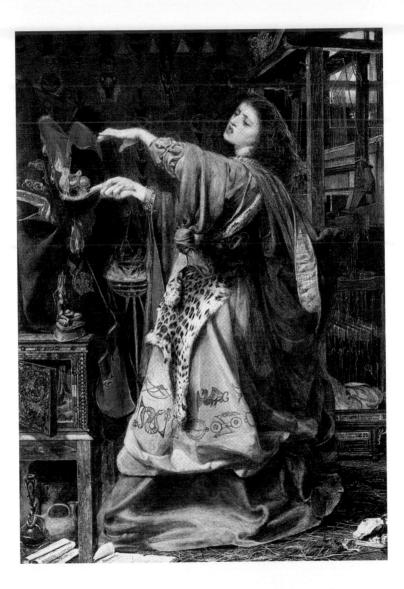

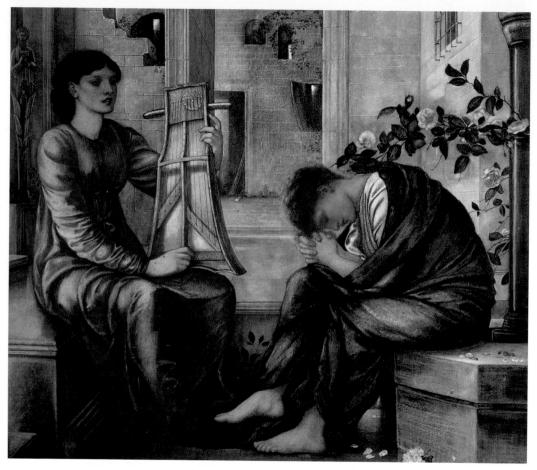

THE LAMENT, Edward Burne-Jones

THE SINGER

With spices, wines, and silken stuffs, The stout ship sailed down, And with the ship the singer came Unto the old sea town.

'Peace to ye!' quoth the sailor folk, 'A month and more have we Been listening to his songs. Ah, God! None sings so sweet as he.'

Up from the wharves the salt wind blew, And filled the steep highway; Seven slender plum trees caught the sun Within a courtyard gray.

Out came the daughter of the king; Oh, very fair was she! She was the whitest bough a-grow, So fair, so fair was she! The singer sang, 'My love,' he sang, 'Is like a white plum-tree!' Then silence fell on house and court; No other word sang he.

The king's daughter, when she was old. Sat in a broidered gown, And spun the flax from her fair fields Oh, it was sweet in town!

Seven plum-trees stood down in the court, Each one was white as milk; The king's daughter rose softly there, Rustling her broidered silk.

'Oh, set the wheel away, my maids, And sing that song to me The singer sang!''My love,' sang they, 'Is like a white plum-tree!'

LIZETTE WOODWORTH REESE

E(HO

Come to me in the silence of the night; Come in the speaking silence of a dream; Come with soft rounded cheeks and eyes as bright As sunlight on a stream; Come back in tears.

O memory, hope, love of finished years.

Oh dream how sweet, too sweet, too bitter sweet. Whose wakening should have been in Paradise, Where souls brimfull of love abide and meet; Where thirsting longing eyes Watch the slow door That opening, letting in, lets out no more.

Yet come to me in dreams, that I may live My very life again though cold in death; Come back to me in dreams, that I may give Pulse for pulse, breath for breath:

Speak low, lean low,

As long ago, my love, how long ago!

CHRISTINA ROSSETTI

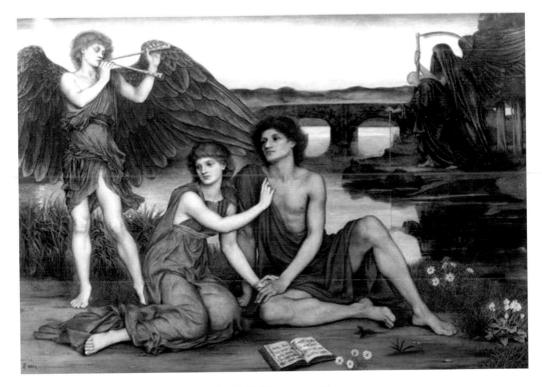

LOVE'S PASSING, Evelyn de Morgan

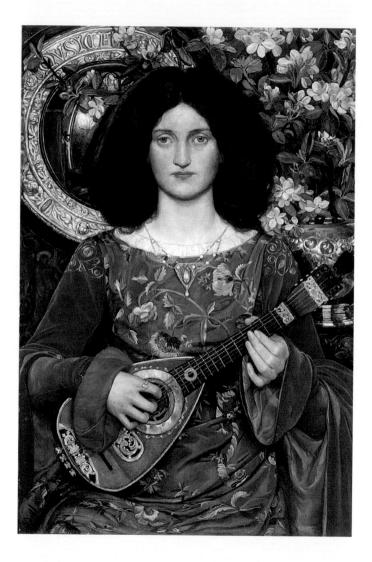

A SHATTERED LUTE

I touched the heart that loved me as a player Touches a lyre. Content with my poor skill, No touch save mine knew my beloved (and still I thought at times: Is there no sweet lost air

Old loves could wake in him, I cannot share?) O he alone, alone could so fulfil

My thoughts in sound to the measure of my will. He is gone, and silence takes me unaware.

The songs I knew not he resumes, set free From my constraining love, alas for me! His part in our tune goes with him; my part

Is locked in me for ever; I stand as mute As one with vigorous music in his heart Whose fingers stray upon a shattered lute.

ALICE MEYNELL

MELODY (MUSICA), KATE ELIZABETH BUNCE

HORA STELLATRIX

The stars hang thick in the apple tree, The south wind smells of the pungent sea, Gold tulip cups are heavy with dew. The night's for you. Sweetheart, for you! Starfire rains from the vaulted blue.

Listen! The dancing of unseen leaves. A drowsy swallow stirs in the eaves. Only a maiden is sorrowing. 'Tis night and spring. Sweetheart, and spring! Starfire lights your heart's blossoming.

In the intimate dark there's never an ear, Though the tulips stand on tiptoe to hear. So give; ripe fruit must shrivel or fall. As you are mine, Sweetheart, give all! Starfire sparkles, your coronal.

AMY LOWELL

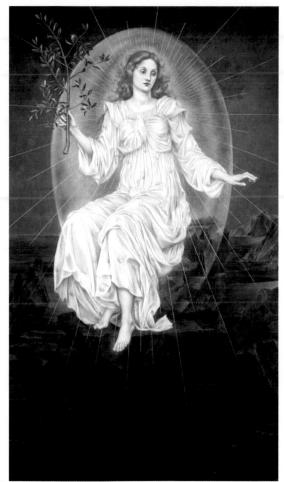

LUX IN TENEBRIS, Evelyn de Morgan

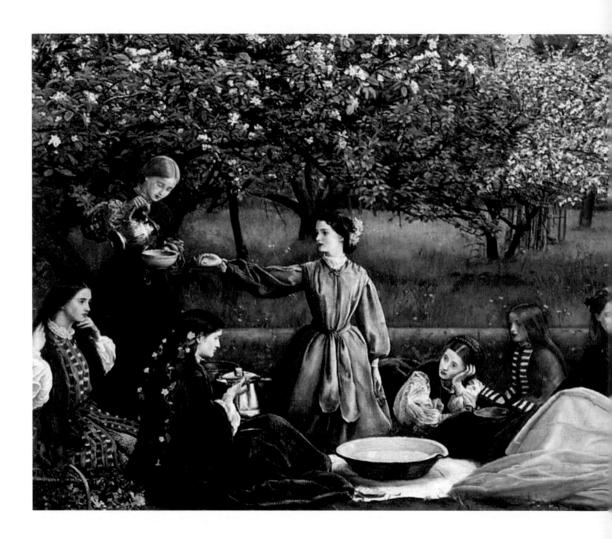

MOMENTS of DELIGHT

My soul is awakened, my spirit is soaring

ANNE BRONTË

SPRING (APPLE BLOSSOMS), JOHN EVERETT MILLAIS

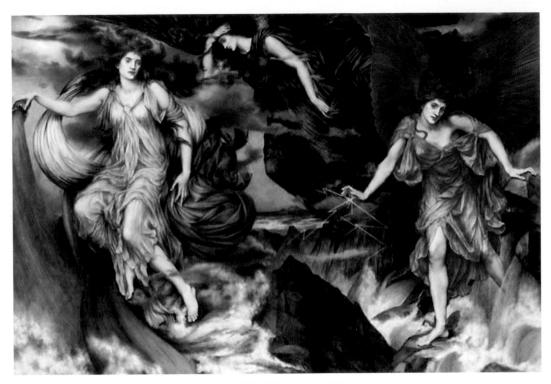

THE STORM SPIRITS, EVELYN DE MORGAN

My soul is awakened, my spirit is soaring And carried aloft on the wings of the breeze; For above and around me the wild wind is roaring, Arousing to rapture the earth and the seas.

The long withered grass in the sunshine is glancing, The bare trees are tossing their branches on high; The dead leaves, beneath them, are merrily dancing. The white clouds are scudding across the blue sky.

I wish I could see how the ocean is lashing The foam of its billows to whirlwinds of spray; I wish I could see how its proud waves are dashing, And hear the wild roar of their thunder to-day!

ANNE BRONTË

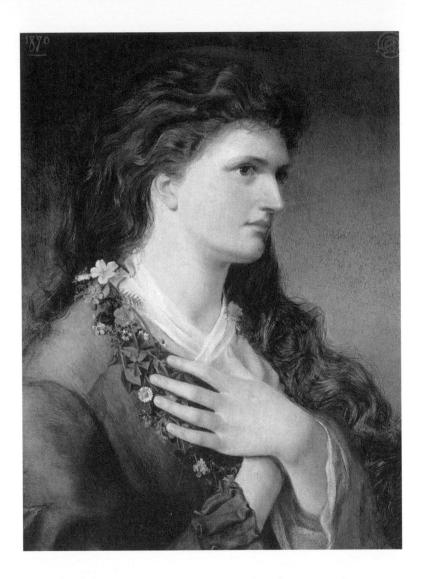

THE BEST THING IN THE WORLD

What's the best thing in the world? June-rose, by May-dew impearled; Sweet south-wind, that means no rain; Truth, not cruel to a friend; Pleasure, not in haste to end; Beauty, not self-decked and curled Till its pride is over-plain; Light, that never makes you wink; Memory, that gives no pain; Love, when, *so*, you're loved again. What's the best thing in the world? —Something out of it, I think.

ELIZABETH BARRETT BROWNING

A NECKLACE OF WILD FLOWERS, EMMA SANDYS

MORNING SONG

Baby darling, wake and see, Morning's here, my little rose; Open eyes and smile at me Ere I clasp and kiss you close. Baby darling, smile! for then Mother sees the sun again.

Baby darling, sleep no more! All the other flowers have done With their sleeping—you, my flower, Are the only sleepy one: All the pink-frilled daisies shout: 'Bring our little sister out!'

Baby darling, in the sun Birds are singing, sweet and shrill; And my bird's the only one That is nested softly still. Baby-if you only knew, All the birds are calling you!

Baby darling all is bright God has brought the sunshine here; And the sleepy silent night Comes back soon enough, my dear! Wake, my darling, night is done, Sunbeams call my little one!

EDITH NESBIT

OUR E LADYE OF GOOD CHILDREN, FORD MADOX BROWN

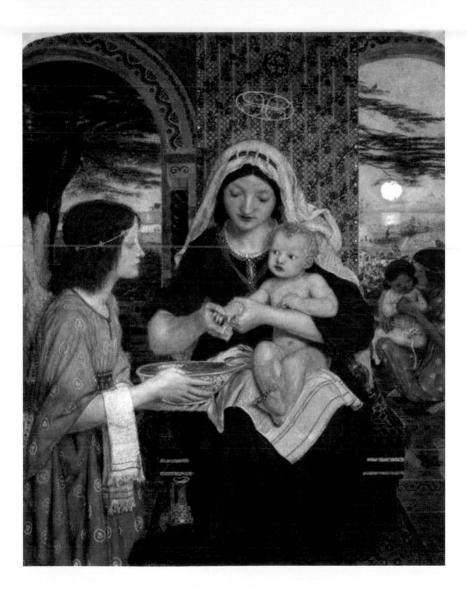

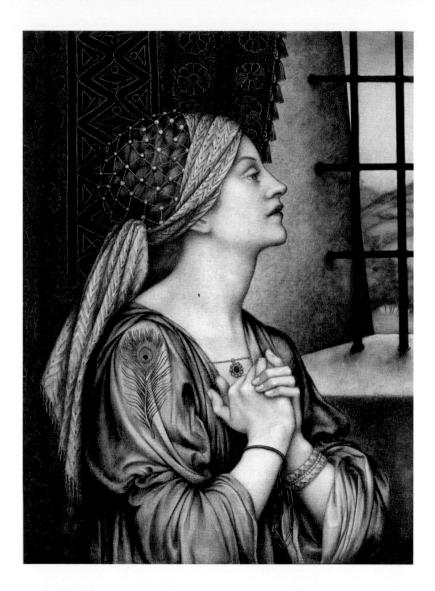

POPPIES º THE WHEAT

Along Ancona's hills the shimmering heat, A tropic tide of air with ebb and flow Bathes all the fields of wheat until they glow Like flashing seas of green, which toss and beat Around the vines. The poppies lithe and fleet Seem running, fiery torchmen, to and fro To mark the shore.

The farmer does not know That they are there. He walks with heavy feet, Counting the bread and wine by autumn's gain, But I,—I smile to think that days remain Perhaps to me in which, though bread be sweet No more, and red wine warm my blood in vain, I shall be glad remembering how the fleet, Lithe poppies ran like torchmen with the wheat.

HELEN JACKSON

THE PRISONER, EVELYN DE MORGAN

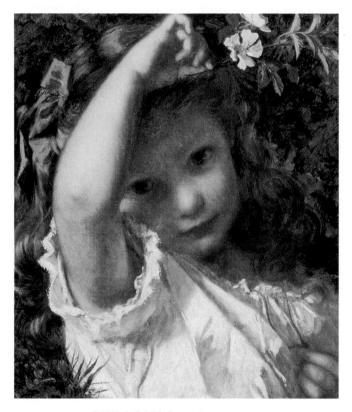

PEEK-A-BOO! SOPHIE ANDERSON

BLACKBERRY BLOSSOMS

Long sunny lane and pike, white, delicate, The blackberry blossoms are ablow, ablow, Hiding the rough-hewn rails 'neath drift of snow, Fresh-fallen, late. The opening pasture gate Brushes a hundred of them loose, and shakes Them down into the tall delicious grass: Sometimes a little sudden wind doth pass, And all the air is full of flying flakes. It seems but yesterday they blew as sweet Down old school ways, and thrilled me with delight; And reaching out for them, I heard the fleet, Glad creek go spinning o'er its pebbles bright. Ah, well! Ah, me! Even now, long as they last, I am a child again; Joy holds me fast.

LIZETTE WOODWORTH REESE

I TASTE ª LIQUOR

I taste a liquor never brewed – From Tankards scooped in Pearl – Not all the Vats upon the Rhine Yield such an Alcohol!

Inebriate of Air – am I – And Debauchee of Dew – Reeling – thro endless summer days – From inns of Molten Blue –

When 'Landlords' turn the drunken Bee Out of the Foxglove's door – When Butterflies – renounce their 'drams' – I shall but drink the more!

Till Seraphs swing their snowy Hats – And Saints – to windows run – To see the little Tippler Leaning against the – Sun –

EMILY DICKINSON

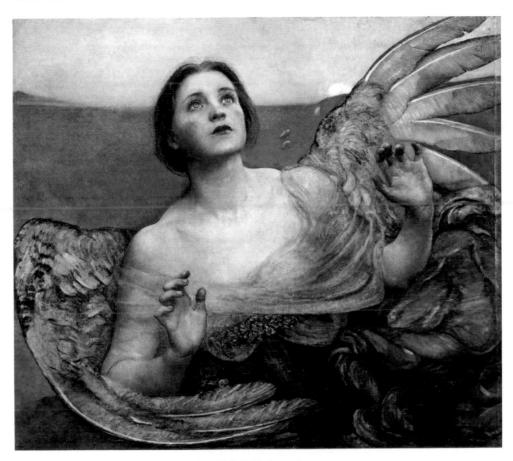

THE SENSE OF SIGHT, ANNIE SWYNNERTON

BROTHER and SISTER

Long years have left their writing on my brow, But yet the freshness and the dew-led beam Of those young mornings are about me now, When we two wandered toward the far-off stream

With rod and line. Our basket held a store Baked for us only, and I thought with joy That I should have my share, though he had more, Because he was the elder and a boy.

The firmaments of daisies since to me I have had those mornings in their opening eyes, The bunched cowslip's pale transparency Carries that sunshine of sweet memories.

And wild-rose branches take their finest seem From those blest hours of infantine content.

No. II of the 'Brother and Sister' sequence

GEORGE ELIOT

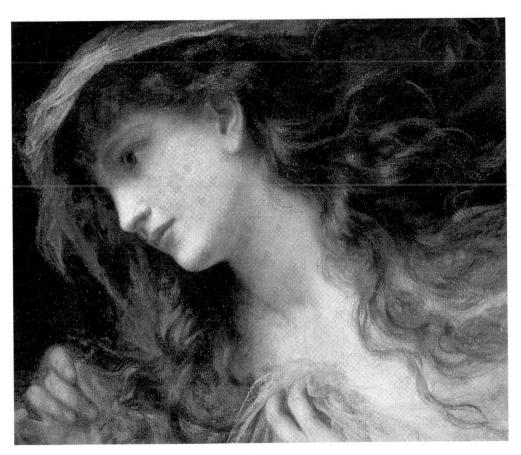

HEAD OF A NYMPH, SOPHIE ANDERSON

THE AUTUMN DAY ILS COURSE Has RUN

The Autumn day its course has run. The Autumn evening falls Already risen the Autumn moon gleams quiet on these walls And Twilight to my lonely house a silent guest is come In mask of gloom through every room she passes dusk and dumb Her veil is spread, her shadow shed o'er stair and chamber void And now I feel her presence steal even to my lone fireside Sit silent Nun—sit there and be Comrade and Confidant to me

CHARLOTTE BRONTË

MARIANA IN THE MOATED GRANGE, JOHN EVERETT MILLAIS

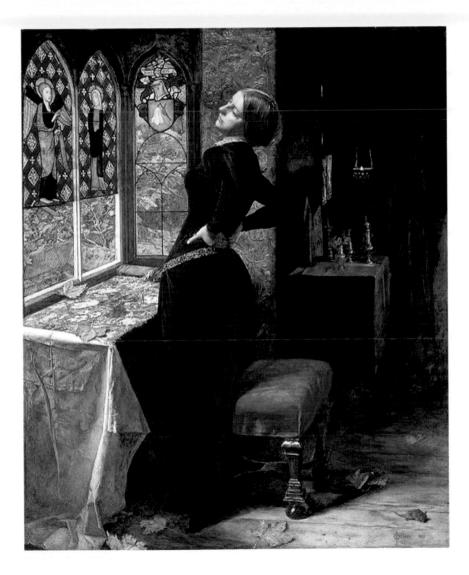

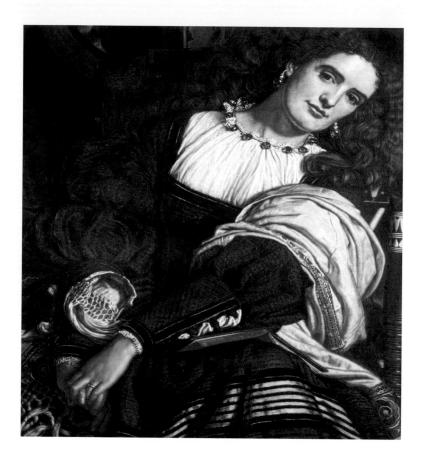

IL DOLCE FAR NIENTE, WILLIAM HOLMAN HUNT

ANOVICE

What is it, in these latter days, Transfigures my domestic ways, And round me, as a halo, plays? My cigarette.

For me so daintily prepared. No modern skill, or perfume, spared. What would have happened had I dared To pass it yet?

What else could lighten times of woe, When someone says 'I told you so,' When all the servants, in a row. Give notices?

When the great family affairs Demand the most gigantic cares And one is very ill upstairs With poultices?

What else could ease my aching head, When, though I long to be in bed, I settle steadily instead To my 'accounts?'

And while the house is slumbering, Go over them like anything, And find them ever varying, In their amounts! Ah yes, the cook may spoil the broth The cream of life resolve to froth, I cannot now, though very wroth, Distracted be;

For as the smoke curls blue and thin From my own lips, I first begin To bathe my tired spirit in Philosophy.

And sweetest healing on her pours, Once more into the world she soars, And sees it full of open doors, And helping hands.

In spite of those who, knocking, stay At sullen portals day by day, And weary at the long delay To their demands.

The promised epoch, like a star. Shines very bright and very far, But nothing shall its lustre mar, Though distant yet.

If I, in vain, must sit and wait, To realize our future state, I shall not be disconsolate, My cigarette!

DOLLIE RADFORD

BEHIND & WALL

I own a solace shut within my heart, A garden lull of quaint delight And warm with drowsy, poppied sunshine; bright, Flaming with lilies out of whose cups dart Shining things With powdered wings.

Here terrace sinks to terrace, arbors close The ends of dreaming paths; a wanton wind Jostles the hall-ripe pears, and then, unkind, Tumbles a-slumber in a pillar rose, With content Grown indolent.

By night my garden is o'erhung with gems Fixed in an onyx setting. Fireflies Flicker their lanterns in my dazzled eyes. In serried rows I guess the straight, stiff stems Of hollyhocks Against the rocks.

So far and still it is that, listening, I hear the flowers talking in the dawn: And where a sunken basin cuts the lawn. Cinctured with iris, pale and glistening. The sudden swish Of a waking fish.

AMY LOWELL

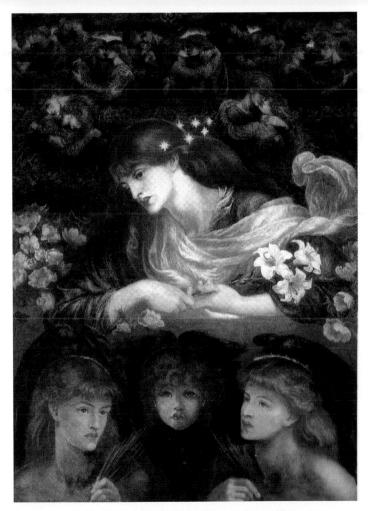

THE BLESSED DAMOZEL, DANTE GABRIEL ROSSETTI

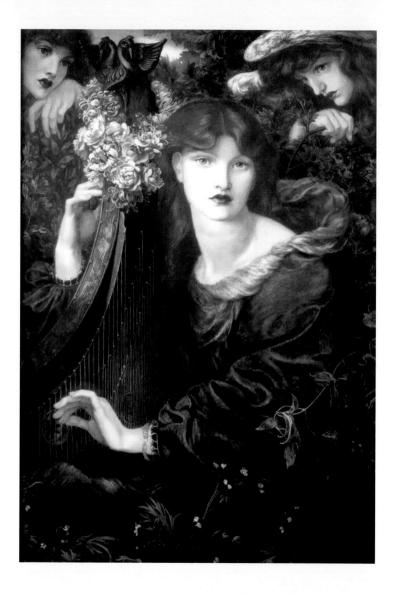

A LOST CHORD

Seated one day at the Organ, I was weary and ill at ease, And my fingers wandered idly Over the noisy keys.

I do not know what I was playing, Or what I was dreaming then; But I struck one chord of music, Like the sound of a great Amen.

It flooded the crimson twilight Like the close of an Angel's Psalm, And it lay on my fevered spirit With a touch of infinite calm.

It quieted pain and sorrow, Like love overcoming strife; It seemed the harmonious echo From our discordant life. It linked all perplexed meanings Into one perfect peace, And trembled away into silence As if it were loth to cease.

I have sought, but I seek it vainly, That one lost chord divine, Which came from the soul of the Organ, And entered into mine.

It may be that Death's bright angel Will speak in that chord again, – It may be that only in Heaven I shall hear that grand Amen.

ADELAIDE ANNE PROCTOR

LA GHIRLANDATA, DANTE GABRIEL ROSSETTI

YOUTH

Sweet empty sky of June without a stain. Faint, gray-blue dewy mists on far-off hills, Warm, yellow sunlight flooding mead and plain,

That each dark copse and hollow overfills; The rippling laugh of unseen, rain-led rills, Weeds delicate-flowered, white and pink and gold, A murmur and a singing manifold.

The gray, austere old earth renews her youth

With dew-lines, sunshine, gossamer, and haze. How still she lies and dreams, and veils the truth, While all is fresh as in the early days! What simple things be these the soul to raise To bounding joy, and make young pulses beat, With nameless pleasure finding life so sweet.

On such a golden morning forth there floats, Between the soft earth and the softer sky,

In the warm air adust with glistening motes,

The mystic winged and flickering butterfly,

A human soul, that hovers giddily Among the gardens of earth's paradise, Nor dreams of fairer fields or loftier skies.

From 'Epochs', a series of sixteen poems: 'The epochs of our life are not in the visible facts, but in the silent thought by the wayside as we walk.' Emerson

EMMA LAZARUS

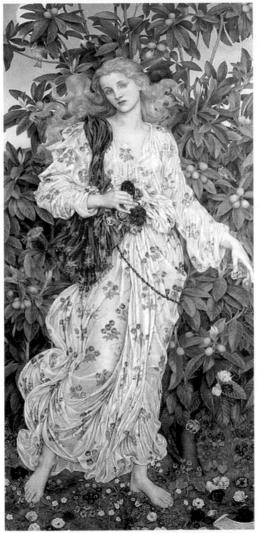

FLORA, Evelyn de Morgan

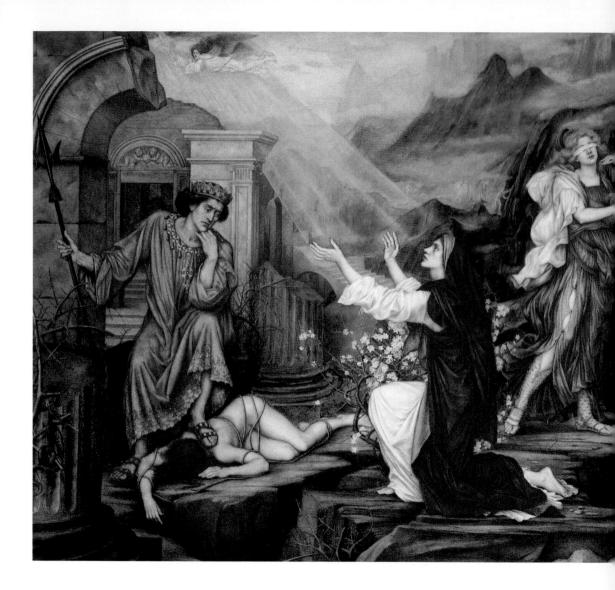

DREAMS and REALLTIES

....that precarious Gait Some call Experience.

EMILY DICKINSON

THE VALLEY OF SHADOWS Evelyn de Morgan

I STEPPED From PLANK to PLANK

I stepped from Plank to Plank A slow and cautious way The Stars about my Head I felt About my Feet the Sea.

I knew not but the next Would be my final inch – This gave me that precarious Gait Some call Experience.

EMILY DICKINSON

DESTINY, JOHN WILLIAM WATERHOUSE

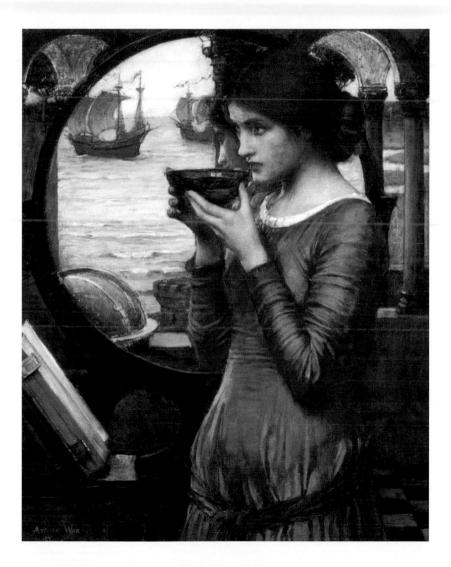

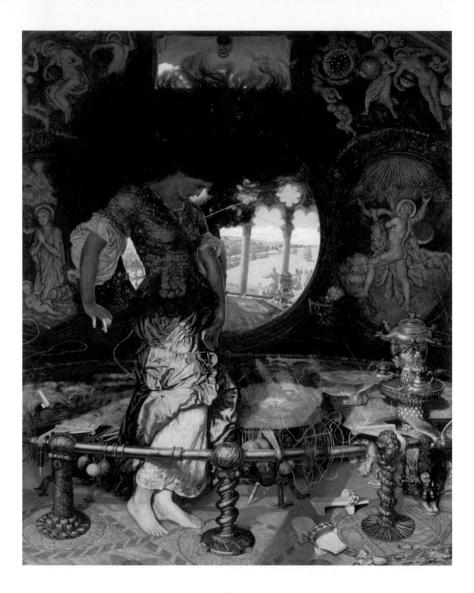

CROSSED THREADS

The silken threads by viewless spinners spun, Which float so idly on the summer air, And help to make each summer morning fair, Shining like silver in the summer sun, Are caught by wayward breezes, one by one, And blown to east and west and fastened there, Weaving on all the roads their sudden snare. No sign which road doth safest, freest run, The winged insects know, that soar so gay To meet their death upon each summer day. How dare we any human deed arraign; Attempt to reckon any moment's cost; Or any pathway trust as safe and plain Because we see not where the threads have crossed?

HELEN JACKSON

THE LADY OF SHALOTT, WILLIAM HOLMAN HUNT

TWO LOVERS

Two lovers by a moss-grown spring: They leaned soft cheeks together there, Mingled the dark and sunny hair, And heard the wooing thrushes sing. O budding time! O love's blest prime!

Two wedded from the portal stept: The bells made happy carollings, The air was soft as fanning wings, White petals on the pathway slept.

> O pure-eved bride! O tender pride!

Two faces o'er a cradle bent: Two hands above the head were locked: These pressed each other while they rocked, Those watched a life that love had sent. O solemn hour! O hidden power!

Two parents by the evening fire: The red light fell about their knees On heads that rose by slow degrees Like buds upon the lily spire O patient life!

O tender strife!

The two still sat together there, The red light shone about their knees; But all the heads by slow degrees Had gone and left that lonely pair. O voyage fast! O vanished past!

The red light shone upon the floor And made the space between them wide; They drew their chairs up side by side. Their pale cheeks joined, and said, 'Once more!' O memories! O past that is!

GEORGE ELIOT

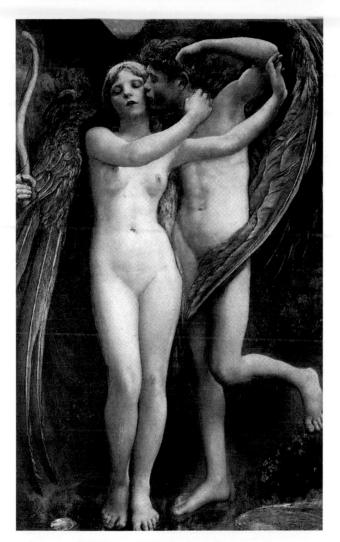

CUPID AND PSYCHE, ANNIE SWYNNERTON

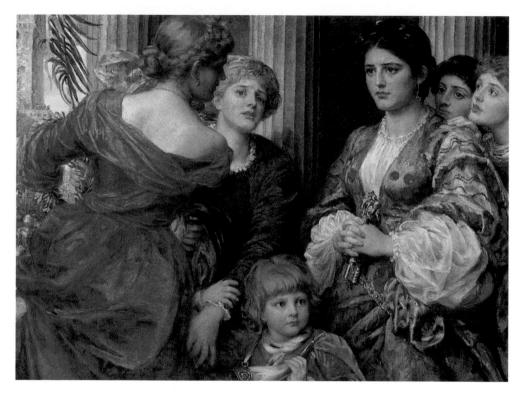

WAR, ANNA LEA MERRITT

GRIEF

I tell you, hopeless grief is passionless; That only men incredulous of despair, Half-taught in anguish, through the midnight air Beat upward to God's throne in loud access Of shrieking and reproach. Full desertness In souls as countries, lieth silent-bare Under the blanching, vertical eye-glare Of the absolute Heavens. Deep-hearted man, express Grief for thy Dead in silence like to death— Most like a monumental statue set In everlasting watch and moveless woe Till itself crumble to the dust beneath. Touch it; the marble eyelids are not wet: If it could weep, it could arise and go.

ELIZABETH BARRETT BROWNING

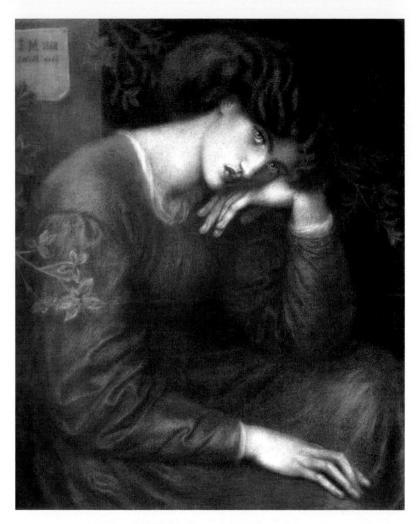

REVERIE, DANTE GABRIEL ROSSETTI

ASCHERZO

With the wasp at the innermost heart of a peach, On a sunny wall out of tip-toe reach, With the trout in the darkest summer pool, With the fern-seed clinging behind its cool Smooth frond, in the chink of an aged tree, In the woodbine's horn with the drunken bee, With the mouse in its nest in a furrow old, With the chrysalis wrapt in its gauzy fold: With things that are hidden, and sale, and bold, With things that are timid, and shy, and free, Wishing to be;

With the nut in its shell, with the seed in its pod, With the corn as it sprouts in the kindly clod, Far down where the secret of beauty shows In the bulb of the tulip, before it blows; With things that are rooted, and firm, and deep, Quiet to lie, and dreamless to sleep; With things that are chainless, and tameless, and proud, With the fire in the jagged thunder-cloud, With the wind in its sleep, with the wind in its waking, With the drops that go to the rainbow's making, Wishing to be with the light leaves shaking, Or stones on some desolate highway breaking: Far up on the hills, where no foot surprises The dew as it falls, or the dust as it rises; To be couched with the beast in its torrid lair, Or drifting on ice with the polar bear, With the weaver at work at his quiet loom; Anywhere, anywhere, out of this room! DORA GREENWELL

PASSING and GLASSING

All things that pass Are woman's looking-glass; They show her how her bloom must fade, And she herself be laid With withered roses in the shade; With withered roses and the fallen peach Unlovely, out of reach Of summer joy that was.

All things that pass Are woman's tiring-glass; The faded lavender is sweet. Sweet the dead violet Culled and laid by and cared for yet; The dried-up violets and dried lavender Still sweet, may comfort her, Nor need she cry Alas!

All things that pass Are wisdom's looking-glass; Being hill of hope and fear, and still Brimful of good or ill. According to our work and will; For there is nothing new beneath the sun; Our doings have been done, And that which shall be was.

CHRISTINA ROSSETTI

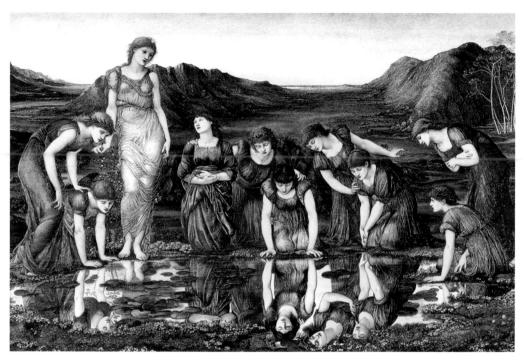

THE MIRROR OF VENUS, Edward Burne-Jones

SOUTUDE

Laugh, and the world laughs with you; Weep, and you weep alone; The sad old earth must borrow its mirth, But has trouble enough of its own. Sing, and the hills will answer; Sigh, it is lost on the air: The echoes bound to a joyful sound, But shrink from voicing care.

Rejoice, and men will seek you: Grieve, and they turn and go; They want full measure of all your pleasure, But they do not need your woe. Be glad, and your friends are many; Be sad, and you lose them all, – There are none to decline your nectared wine, But alone you must drink life's gall.

Feast, and your halls are crowded;Fast, and the world goes by.Succeed and give, and it helps you live,But no man can help you die.There is room in the halls of pleasureFor a large and lordly train,But one by one we must all file onThrough the narrow aisles of pain.

ELLA WHEELER WILCOX

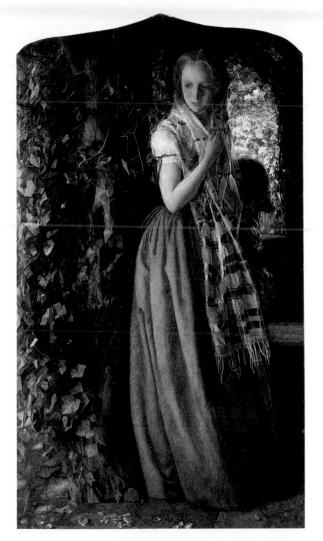

APRIL LOVE, ARTHUR HUGHES

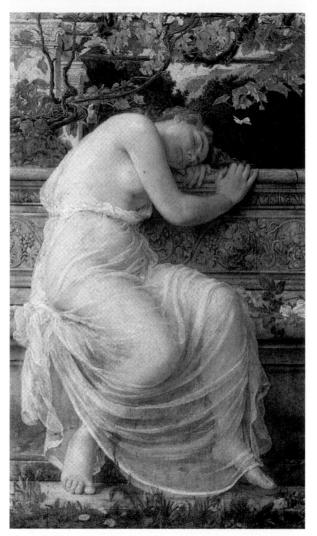

THE SLEEPING GIRL, EDITH ELLENBOROUGH CORBET

WORN OUT

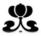

Thy strong arms are around me, love, My head is on thy breast: Though words of comfort come from thee, My soul is not at rest:

For I am but a startled thing, Nor can I ever be Aught save a bird whose broken wing Must fly away from thee.

I cannot give to thee the love I gave so long ago -The love that turned and struck me down Amid the blinding snow.

I can but give a sinking heart And weary eyes of pain, A faded mouth that cannot smile And may not laugh again.

Yet keep thine arms around me, love, Until I drop to sleep: Then leave me - saying no good-bye. Lest I might fall and weep.

ELIZABETH SIDDAL

PETALS

Life is a stream On which we strew Petal by petal the flower of our heart; The end lost in dream, They float past our view, We only watch their glad, early start.

Freighted with hope, Crimsoned with joy, We scatter the leaves of our opening rose; Their widening scope, Their distant employ, We never shall know. And the stream as it flows

Sweeps them away, Each one is gone Ever beyond into infinite ways. We alone stay While years hurry on, The flower fared forth, though its fragrance still stays.

AMY LOWELL

THE ROSE FROM ARMIDA'S GARDEN, Marie Spartali Stillman

THE OLD STOIC

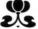

Riches I hold in light esteem; And Love I laugh to scorn; And lust of fame was but a dream That vanished with the morn:

And if I pray, the only prayer That moves my lips for me Is, 'Leave the heart that now I bear. And give me liberty!'

Yes, as my swift days near their goal, 'Tis all that I implore; In life and death, a chainless soul. With courage to endure.

EMILY JANE BRONTË

THE WORSHIP OF MAMMON, EVELYN DE MORGAN

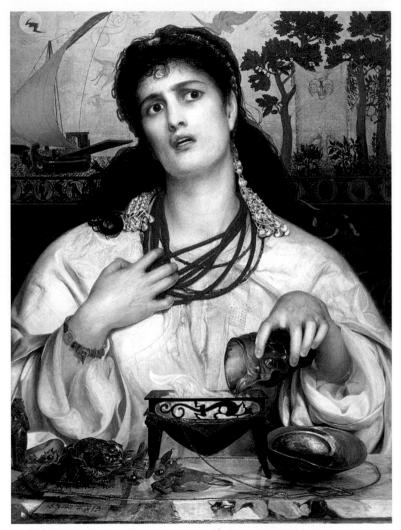

MEDEA, ANTHONY FREDERICK SANDYS

THE OTHER SIDE of a MIRROR

I sat before my glass one day, And conjured up a vision bare, Unlike the aspects glad and gay, That erst were found reflected there – The vision of a woman, wild With more than womanly despair.

Her hair stood back on either side A face bereft of loveliness. It had no envy now to hide What once no man on earth could guess. It formed the thorny aureole Of hard, unsanctified distress.

Her lips were open – not a sound Came through the parted lines of red, Whate'er it was, the hideous wound In silence and in secret bled. No sigh relieved her speechless woe, She had no voice to speak her dread. And in her lurid eyes there shone The dying flame of life's desire, Made mad because its hope was gone, And kindled at the leaping fire Of jealousy and fierce revenge, And strength that could not change nor tire.

Shade of a shadow in the glass, O set the crystal surface free! Pass – as the fairer visions pass – Nor ever more return, to be The ghost of a distracted hour, That heard me whisper: – 'I am she!'

MARY ELIZABETH COLERIDGE

UP-HILL

Does the road wind up-hill all the way? Yes, to the very end. Will the day's journey take the whole long day? From morn to night, my friend.

But is there for the night a resting-place? A roof for when the slow dark hours begin. May not the darkness hide it from my face? You cannot miss that inn.

Shall I meet other wayfarers at night? Those who have gone before. Then must I knock, or call when just in sight? They will not keep you standing at that door.

Shall I find comfort, travel-sore and weak? Of labour you shall find the sum. Will there be beds for me and all who seek? Yea, beds for all who come.

CHRISTINA ROSSETTI

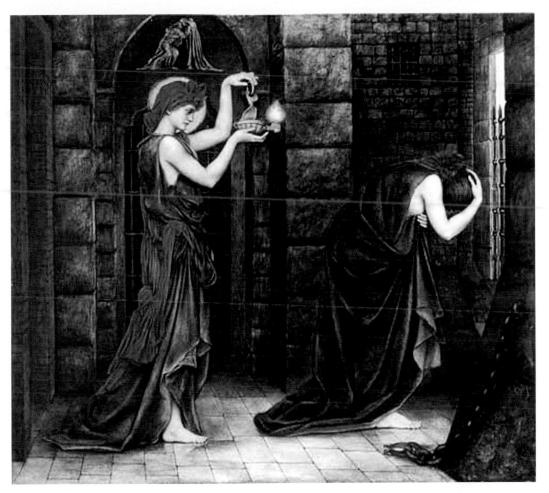

HOPE IN THE PRISON OF DESPAIR, EVELYN DE MORGAN

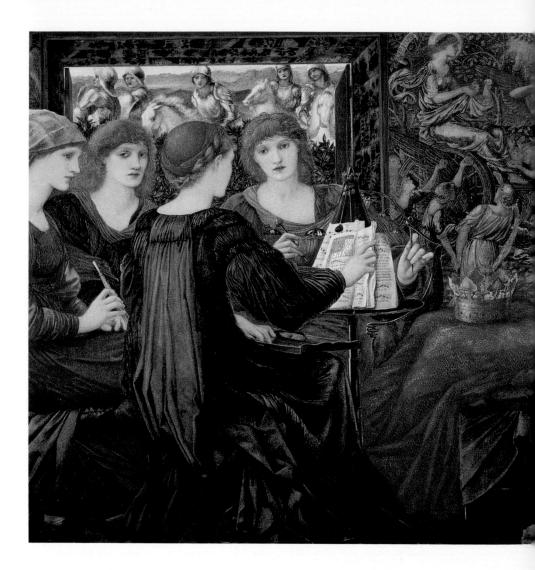

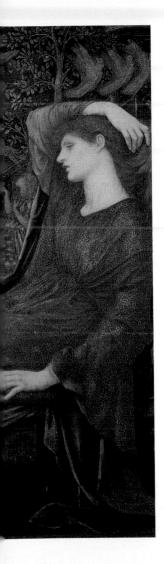

LAST SONGS

'Tis death, the spider, in his net, Who lures the dancers as they glide,

DORA SIGERSON SHORTER

LAUS VENERIS, Edward Burne-Jones

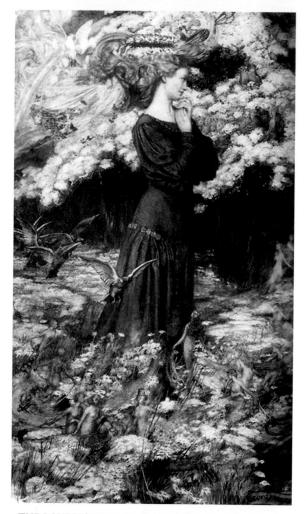

THE LOVERS'S WORLD, ELEANOR FORTESCUE-BRICKDALE

THE WATCHER IN THE WOOD

Deep in the wood's recesses cool I see the fairy dancers glide, In cloth of gold, in gown of green, My lord and lady side by side.

But who has hung from leaf to leaf, From flower to flower, a silken twine – A cloud of grey that holds the dew In globes of clear enchanted wine?

Or stretches far from branch to branch, From thorn to thorn, in diamond rain, Who caught the cup of crystal pure And hung so fair the shining chain?

'Tis death, the spider, in his net, Who lures the dancers as they glide, In cloth of gold, in gown of green, My lord and lady side by side,

DORA SIGERSON SHORTER

A REMINISCENCE

Yes, thou art gone! and never more Thy sunny smile shall gladden me; But I may pass the old church door, And pace the floor that covers thee,

May stand upon the cold, damp stone, And think that, frozen, lies below The lightest heart that I have known, The kindest I shall ever know.

Yet, though I cannot see thee more, 'Tis still a comfort to have seen; And though thy transient life is o'er. 'Tis sweet to think that thou hast been;

To think a soul so near divine, Within a form, so angel fair, United to a heart like thine. Has gladdened once our humble sphere.

ANNE BRONTË

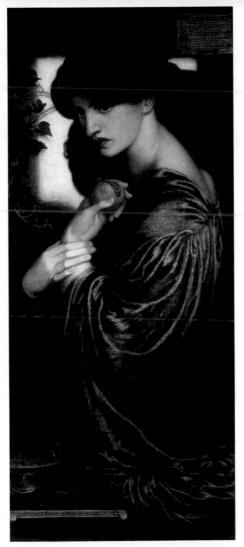

PROSERPINE, Dante Gabriel Rossetti

ANEND

Love, strong as Death, is dead. Come, let us make his bed Among the dying flowers: A green turf at his head; And a stone at his feet, Whereon we may sit In the quiet evening hours.

He was born in the Spring, And died before the harvesting: On the last warm summer day He left us; he would not stay For Autumn twilight cold and grey. Sit we by his grave, and sing He is gone away.

To few chords and sad and low Sing we so: Be our eyes fixed on the grass Shadow-veiled as the years pass, While we think of all that was In the long ago.

CHRISTINA ROSSETTI

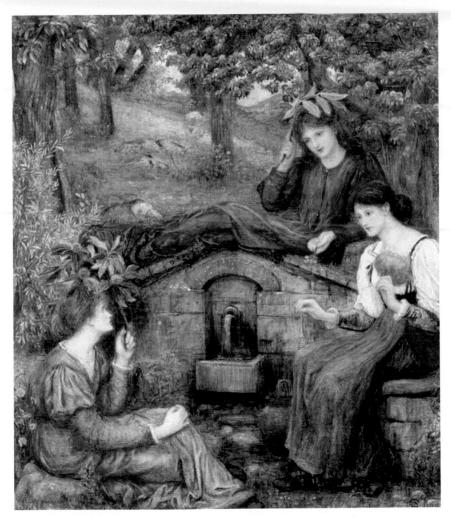

BY A CLEAR WELL, WITHIN A LITTLE FIELD, MARIE SPARTALI STILLMAN

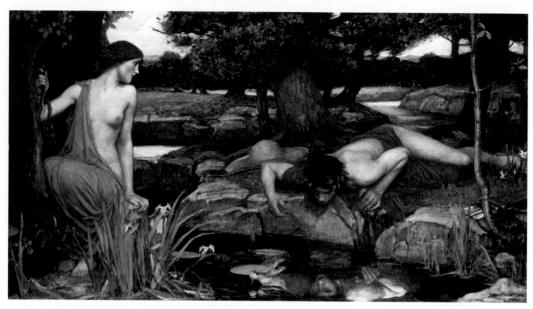

ECHO AND NARCISSUS, JOHN WILLIAM WATERHOUSE

I DIED for BEAUTY

I died for Beauty - but was scarce Adjusted in the Tomb When One who died for Truth, was lain In an adjoining Room -

He questioned softly 'Why I failed'? 'For Beauty', I replied – 'And I – for Truth – Themself are One – We Brethren, are', He said –

And so, as Kinsmen, met a Night – We talked between the Rooms – Until the Moss had reached our lips – And covered up – our names –

EMILY DICKINSON

REMEMBRANCE

Cold on the earth - and the deep snow piled above thee, Far, far removed, cold in the dreary grave!

Have I forgot, my only Love, to love thee, Severed at last by Time's all-severing wave?

Now, when alone, do my thoughts no longer hover Over the mountains, on that northern shore, Resting their wings where heath and fern-leaves cover Thy noble heart for ever, ever more?

Cold in the earth - and fifteen wild Decembers, From those brown hills, have melted into spring: Faithful, indeed, is the spirit that remembers After such years of change and suffering!

Sweet Love of youth, forgive, if I forget thee, While the world's tide is bearing me along; Other desires and other hopes beset me, Hope which obscure, but cannot do thee wrong! No later light has lightened up my heaven. No second morn has ever shone for me; All my life's bliss from thy dear life was given, All my life's bliss is in the grave with thee.

But, when the days of golden dreams had perished, And even Despair was powerless to destroy: Then did I learn how existence could be cherished, Strengthened, and fed without the aid of joy.

Then did I check the tears of useless passion Weaned my young soul from yearning after thine: Sternly denied its burning wish to hasten Down to that tomb already more than mine.

And, even yet, I dare not let it languish, Dare not indulge in memory's rapturous pain; Once drinking deep of that divinest anguish, How could I seek the empty world again?

EMILY JANE BRONTË

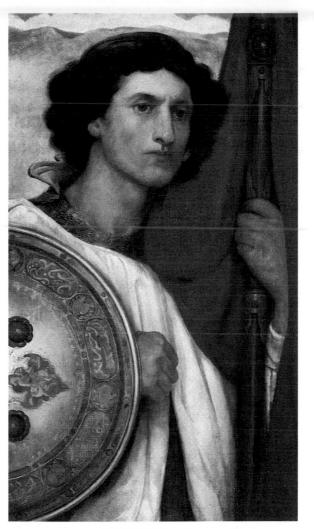

A KNIGHT, KATE ELIZABETH BUNCE

ON the THRESHOLD

O God, my dream! I dreamed that you were dead; Your mother hung above the couch and wept Whereon you lay all white, and garlanded With blooms of waxen whiteness. I had crept Up to your chamber-door, which stood ajar, And in the doorway watched you from afar, Nor dared advance to kiss your lips and brow. I had no part nor lot in you as now; Death had not broken between us the old bar; Nor torn from out my heart the old, cold sense Of your misprision and my impotence.

AMY LEVY

MAY MORRIS, DANTE GABRIEL ROSSETTI

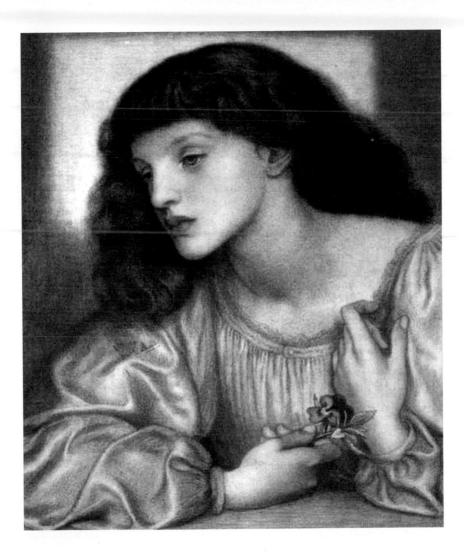

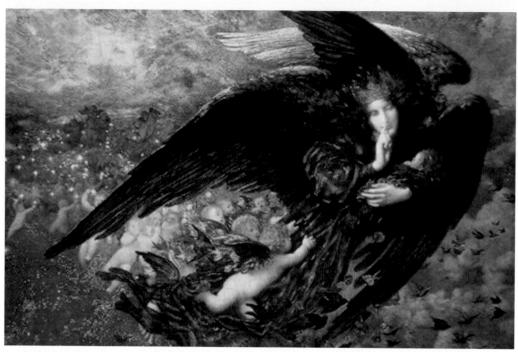

NIGHT WITH HER TRAIN OF STARS AND HER GREAT GIFT OF SLEEP, EDWARD ROBERT HUGHES

MATERNITY

One wept whose only child was dead, New-born, ten years ago. 'Weep not; he is in bliss,' they said. She answered. 'Even so.

Ten years ago was born in pain A child, not now forlorn, But oh, ten years ago, in vain, A mother, a mother was born.'

ALICE MEYNELL

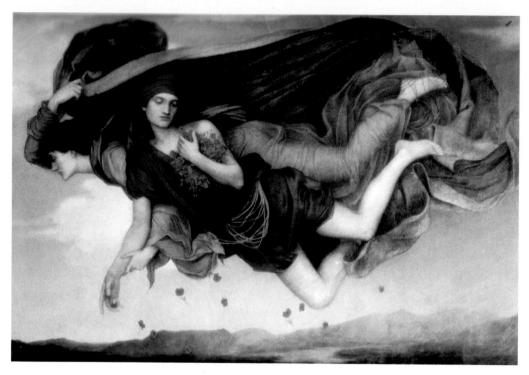

NIGHT AND SLEEP, EVELYN DE MORGAN

Cold, my dear, - cold and quiet, In their cups on yonder lea, Cowslips fold the brown bee's diet; So the moss enfoldeth thee. 'Plant me, plant me, O love, a lily flower -Plant at my head, I pray you, a green tree; And when our children sleep.' she sighed, 'at the dusk hour, And when the lily blossoms, O come out to me!'

Lost, my dear? Lost! nay, deepest Love is that which loseth least: Through the night-time while thou sleepest, Still I watch the shrouded east. Near thee, near thee, my wife that ave liveth, 'Lost' is no word for such a love as mine; Love from her past to me a present giveth, And love itself doth comfort, making pain divine.

Rest, my dear, rest. Fair showeth That which was, and not in vain: Sacred have I kept, God knoweth, Love's last words atween us twain. 'Hold by our past, my only love, my lover; Fall not, but rise, O love, by loss of me!' Boughs from our garden, white with bloom hang over. Love, now the children slumber, I come out to thee.

JEAN INGELOW

LAST WORDS

Dear hearts, whose love has been so sweet to know, That I am looking backward as I go, Am lingering while I haste, and in this rain Of tears of joy am mingling tears of pain; Do not adorn with costly shrub, or tree, Or flower, the little grave which shelters me. Let the wild wind-sown seeds grow up unharmed, And back and forth all summer, unalarmed, Let all the tiny, busy creatures creep; Let the sweet grass its last year's tangles keep; And when, remembering me, you come some day And stand there, speak no praise, but only say, 'How she loved us! 'Twas that which made her dear!' Those are the words that I shall joy to hear.

HELEN JACKSON

THE BELOVED, DANTE GABRIEL ROSSETTI

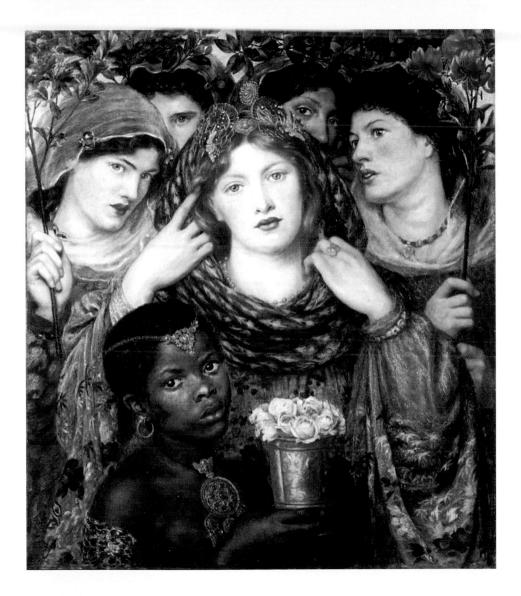

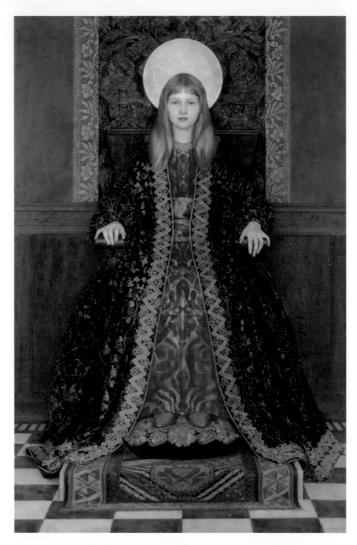

THE CHILD ENTHRONED, THOMAS COOPER GOTCH

YOUTH and DEATH

What hast thou done to this dear friend of mine, Thou cold, white, silent Stranger? From my hand Her clasped hand slips to meet the grasp of thine; Her eyes that flamed with love, at thy command Stare stone-blank on blank air; her frozen heart Forgets my presence. Teach me who thou art, Vague shadow sliding 'twixt my friend and me.

I never saw thee till this sudden hour. What secret door gave entrance unto thee?

What power is thine, o'ermastering Love's own power?

AGE and DEATH

Come closer, kind, white, long familiar friend,

Embrace me, fold me to thy broad soft breast. Life has grown strange and cold, but thou dost bend

Mild eyes of blessing wooing to my rest. So often hast thou come, and from my side So many hast thou lured, I only bide Thy beck, to follow glad thy steps divine.

Thy world is peopled for me; this world's bare.

Through all these years my couch thou didst prepare. Thou art supreme Love—kiss me—I am thine!

EMMA LAZARUS

SONG

When I am dead, my dearest, Sing no sad songs for me; Plant thou no roses at my head, Nor shady cypress tree: Be the green grass above me With showers and dewdrops wet; And if thou wilt, remember, And if thou wilt, forget.

I shall not see the shadows, I shall not feel the rain; I shall not hear the nightingale Sing on, as if in pain: And dreaming through the twilight That doth not rise nor set Haply I may remember, And haply may forget.

CHRISTINA ROSSETTI

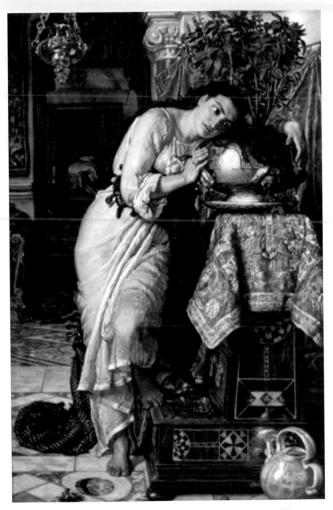

ISABELLA AND THE POT OF BASIL, WILLIAM HOLMAN HUNT

THE POETS

Biographical information and text acknowledgements

Anne Brontë (1820-1849) was the youngest of the three Brontë sisters, whose heroic struggles against isolation and poverty secured a posthumous fame that continues to attract visitors from all over the world to their remote parsonage home in the tiny Yorkshire village of Haworth. 'A Reminiscence' perhaps refers to Anne Brontë's suggested attachment to her father's curate, William Weightman, who died at the early age of 28. 'A Windy Day' (full title 'Lines Composed in a Wood on a Windy Day') expresses her characteristic delight in the freedom of nature. Both poems from Poems by Currer, Ellis and Acton Bell (London, 1846).

Charlotte Brontë (1816-55) is more famous as a creator of indomitable heroines than as a poet. 'The Autumn Day its Course has Run', scribbled in her German exercise book, used when she was studying, teaching – and falling in love – in Brussels, shows the writer in a characteristically thoughtful mood, sensitive and responsive to the natural world: transcribed from MS 118 in The Bonnell Collection, Brontë Museum, Haworth. By courtesy of the Brontë Society.

Emily Jane Brontë (1818-48) is outstanding both as the creator of the demoniac Heathcliff in Wuthering Heights and for her poetic gifts. All four surviving Brontë children wrote imaginative sagas which continued well into their adult lives. 'Remembrance' is the passionate lament of Rosina Alcona, the Queen of Gondal, for her beloved Julius, assassinated by rebels fifteen years previously but still achingly present in her memory. 'Love and Friendship': from *Wuthering Heights and Agnes Grey by Ellis and Acton Bell*, with A Selection from their Literary Remains (London, 1850); 'Remembrance' and 'The Old Stoic' from *Poems by Currer, Ellis, and Acton Bell* (London, 1846).

The clandestine love affair of Elizabeth Barrett Browning (1806-61) with the poet Robert Browning and their subsequent elopement after she had lived as an invalid for many years constitute one of the great Victorian romances. The 'Sonnets from the Portuguese' were written during Browning's courtship but not shown to him until three years after they were married. Because of their intimate and erotic content. Elizabeth Barrett Browning published them as translations from original works written in Portuguese. 'Go From Me': from 'Sonnets from the Portuguese' Vol. III, Elizabeth Barrett Browning's Poetical Works (London, 1816); 'Grief' from Vol.

II (op. cit.); 'The Best Thing in the World' from Vol. IV (op. cit.).

Mary Elizabeth Coleridge (1861–1907) was related to the poet Samuel Taylor Coleridge. Novelist as well as poet, her poems were published in her lifetime under the pseudonym Anodos. 'The Other Side of a Mirror' was published in a slender volume in the publishers Elkin Mathews' charming 'Shilling Garland' series, and offers a surprisingly modern treatment of the problem of identity from *Fancy's Guerdon* by Anodos (London, 1897).

Emily Dickinson (1830-86) lived all her life at her family home in Amherst, Massachusetts. Increasingly reclusive, she wrote a substantial number of poems (almost 1800 survive), of which only a handful were published in her lifetime. On seeking advice on her work from the editor of The Atlantic Monthly, she was advised to make her poems more 'regular', and the complete texts with their unconventional punctuation were not published until the 1950s. Her poetry explores the 'great themes': the nature of life and death, love and friendship, and the existence of God. In form and content, they are startlingly original and reward careful re-reading. Reprinted by permission of the publishers and the Trustees of Amherst College from *The Poems of Emily Dickinson*, Thomas H. Johnson, ed., Cambridge, Mass.; The Belknap Press of Harvard University Press, Copyright 1951 © 1955, 1979, 1983, by the President and Fellows of Harvard College.

George Eliot (1819–80), born Mary Anne Evans, is principally known as a great Victorian novelist. She came late to fiction, publishing her first stories when she was 37, but poetry was also an important means of expression for her. The 'Brother and Sister' series celebrates her memories of her beloved brother Isaac, from whom she was estranged for many years when she chose to live with a married man, the writer George Henry Lewes. 'Brother and Sister II' and 'Two Lovers' from *The Legend of Jubal and Other Poems*, Old and New (London, 1879).

Dora Greenwell (1821-82) knew the poet Christina Rossetti and shared her keen interest in theology. She was an advocate of better education for intelligent women and supported the struggle for women to win the vote. Her essays and poems reflect these enthusiasms, and also explore human relationships with gentle irony. 'A Scherzo (A Shy Person's Wishes)'offers a half-humorous, half-painful description of social embarrassment and suggests a strong sympathy with the freedom and privacy of the natural world: from *Poems* (London, 1867).

Jean Ingelow (1820-97) wrote novels and childrens books as well as publishing poetry that was highly valued in her lifetime, to the extent that a group of American authors petitioned Queen Victoria to make her Poet Laureate. She knew members of the literary élite-Tennyson and Browning, as well as Christina Rossetti-but remained a shy woman who never married:'If I had married, I should not have written books." 'The Long White Seam' appeals by its simple rhythmical expression of romantic feeling: a young sailor returns home to see his betrothed sewing her wedding veil. 'Cold and Quiet' and 'The Long White Seam' from Poems, Vol. 2 (London, 1880).

Helen Jackson (1830-85) was born, like her friend Emily Dickinson, in Amherst, Massachusetts. She became a more public figure than Dickinson, a powerful advocate of Indian rights and a prolific writer of articles and book reviews, although she published much of her work under masculine-sounding pseudonyms as she believed publicity was indecorous for women. She married twice, refusing her second husband until he agreed she should be completely free to explore her own interests. Her poetry was popular in her lifetime and the poems selected for this anthology show a sympathetic understanding of human character and an awareness of the unpredictability of fate. 'Crossed Threads', 'Last Words' and 'Poppies on the Wheat' from *Poems* (USA, 1895).

Emma Lazarus (1849-87) was brought up in a wealthy and cultured Jewish family in New York, but did not become an active Zionist until the Russian pogroms in the 1880s. Lines from her poem 'The New Colossus' are inscribed at the foot of the Statue of Liberty: 'Give me your tired, your poor, / Your huddled masses yearning to breathe free, ... Send these, the homeless, tempest-tost to me, / I lift my lamp beside the golden door!' 'The Elixir' Youth', 'Youth and Death' and 'Age and Death' from *The Poems of Emma Lazarus, Vol, I* (USA, 1889).

Amy Levy (1861-89), born in Clapham, was also a Jewish poet and novelist, although her poems deal more specifically with urban themes. Her first poem was published when she was 13, and she continued to write poems and fiction until her premature death from suicide. 'On the Threshold' from *A London Plane-Tree and other Verse* (London, 1889).

Amy Lowell (1874-1925) lived the busy social life of a Boston debutante before writing her first poetry in the early 1900s. In her later work she developed Imagist forms and ideas, but the poems published here are non-experimental. They reveal her voluptuous joy in natural beauty, combined in 'Hora Stellatrix' with a daring eroticism. 'Behind a Wall', 'Hora Stellatrix' and 'Petals' from *A Dome of Many-Coloured Glass* (USA, 1912).

Alice Meynell (1847-1922) and her sister Elizabeth, later Lady Butler and famous for her fine paintings of military subjects, lived mainly in Europe as children. Her first volume of poems was well-received by Ruskin and George Eliot and, with eight children to support and a meagre income, Meynell became a productive poet, essayist and journalist, including writing as Art Critic for *The Pall Mall Gazette*. She was also active in the suffragette movement. 'A Shattered Lute' and 'Maternity' from *Collected Poems of Alice Meynell* (London, 1913).

Edith Nesbit (1858-1924) is best known for her books for children which include classic favourites such as *The Treasure Seekers* and *Five Children and It*. She and her husband Hubert Bland led a somewhat unconventional life by late Victorian standards: Edith took lovers and cared for two of her husband's 'love' children as well as three of their own, and took to her pen in order to make an income for their growing family. 'Morning Song' from *Leaves of Life* (London and USA, 1888).

Adelaide Anne Procter (1825-64)published poems in Charles Dickens' Household Words under the pseudonym Mary Berwick. In his introduction to her Legends and Lyrics. Dickens described how, having never met his mysterious contributor, he had imagined her to be a very efficient governess, returned after many years in Italy with one family: 'my mother was not a more real personage to me, than Miss Berwick the governess became'. He was therefore astonished to discover that Miss B. was in fact the daughter of one of his closest friends and had written to him anonymously to ensure an honest response to her work. 'A Love Token' and 'A Lost Chord' from The Complete Works of Adelaide Anne Procter (London, 1905).

Little is known about the life of **Dollie Radford** (1858-?). She wrote a number of charming poems that reveal both lyric gifts and an endearing ability to laugh at herself, but even the date of her death remains obscure. 'A Novice' from *Songs and Other Verses* (London and USA, 1895).

Lizette Woodworth Reese (1856-1935) was born in a country area in Maryland which she saw grow into the city of Baltimore. For many years she taught English literature and composition, as well as publishing nine volumes of poetry, reminiscences and stories of her girlhood and an autobiographical novel. Her poetry

attracts both by its lyricism and by her interest in pinpointing and communicating emotion. 'Blackberry Blossoms' and 'The Singer' from *A Handful of Lavender* (USA, 1891).

Of **Christina Rossetti** (1830-94),Virginia Woolf wrote that some of her poems 'will be found adhering in perfect symmetry when the Albert Memorial is dust and tinsel'. Sister and sometime model to the flamboyant Pre-Raphaelite artist and poet Dante Gabriel Rossetti, Christina quietly pursued her vocation, resisting marriage and the claims of children in order to write and oversee the publication of her work. 'A Birthday', 'An End', 'Echo', 'Song' and 'Up-hill from *Goblin Market and Other Poems'* (London, 1865) 'Passing and Glassing' from *A Pageant and Other Poems* (London 1881).

Elizabeth Siddal (1829-1862) is still chiefly remembered as the flame-haired model for the Pre-Raphaelites, but she was an artist in her own right and her work is now being discovered and exhibited. The poem 'Worn Out' perhaps describes her feelings towards her husband Dante Gabriel Rossetti; their complex relationship and her hopes of developing an independent life as an artist were ended with her death from laudanum at the age of thirty-two. 'Worn Out' from *Ruskin: Rossetti: Pre-Raphaelitism*, Papers 1854 to 1862, ed. William Michael Rossetti (London, 1899).

Dora Sigerson Shorter (1866-1918) was born in Dublin and continued to be fiercely patriotic after her move to London on marrying the critic and editor Clement Shorter. As well as being a substantially published poet, she was a sculptor, again focusing on Irish themes in works such as the memorial group to the patriots in the 1916 Easter Rebellion. 'The Mountain Maid' and 'The Watcher in the Wood': from *The Collected Poems of Dora Sigerson Shorter* (London, 1907).

Brought up in Wisconsin, **Ella Wheeler Wilcox** (1850-1919) was an enthusiastic versifier from an early age and achieved notoriety with her *Poems of Passion*, which a Chicago publisher rejected on grounds of immorality, but which went on to sell 60,000 copies in two years. During the First World War, she toured Allied Army camps in France, reading her poetry to the troops and admonishing them on clean living. Her much-anthologised poem 'Solitude' exhibits the qualities which ensured her wide popular appeal: from *The Collected Poems of Ella Wheeler Wilcox* Vol. I (London, 1917).

INDEX of FIRST LINES:

All things that pass	76
Along Ancona's hills the shimmering heat	47
As I came round the harbour buoy	21
Baby darling, wake and see	44
Cold in the earth	100
Cold my dear,—cold and quiet	107
Come closer, kind, white, long-familiar friend	111
Come to me in the silence of the night	32
Dcar hcarts, whose love has been so sweet	108
Deep in the wood's recesses cool	73
Do you grieve no costly offering	17
Does the road wind up-hill all the way	88
Go from me. Yet I feel that I shall stand	18
Half seated on a mossy crag	26
I died for Beauty - but was scarce	99
I own a solace shut within my heart	58
I sat before my glass one day	87
I stepped from Plank to Plank	66
I taste a liquor never brewed	50
I tell you, hopeless grief is passionless	73
I touched the heart that loved me as a player	35
Laugh, and the world laughs with you	78
Life is a stream	82
Long sunny lane and pike, white, delicate	49

Loi	ng years have left their writing on my bro	w 52
Lov	ve is like the wild rose-briar	14
Lov	ve, strong as Death, is dead	96
My	heart is like a singing bird	25
My	soul is awakened, my spirit is soaring	41
0	God, my dream!	102
Oh	brew me a potion, strong and good	28
On	e wept whose only child was dead	105
Ric	thes I hold in light esteem	84
Sea	ted one day at the Organ	61
Sw	eet empty sky of June without a stain	62
Th	e Autumn day its course has run	54
Th	e silken threads by viewless spinners spun	69
Th	e stars hang thick in the apple tree	36
Th	y strong arms are around me, love	81
Tw	o lovers by a moss-grown spring	70
W	hat hast thou done to this dear friend	111
Wł	nat is it, in these latter days	57
Wł	nat's the best thing in the world?	43
Wł	nen I am dead, my dearest	112
Wi	ld Nights—Wild Nights	22
Wi	th spices, wines, and silken stuffs	31
With the wasp at the innermost heart of a peach 75		
Yes	thou art gone! and never more	94